# Scavullo

# Nudes

Edited by Ruth Peltason and Judith Hudson
Introduction by David Leddick

Harry N. Abrams, Inc., Publishers

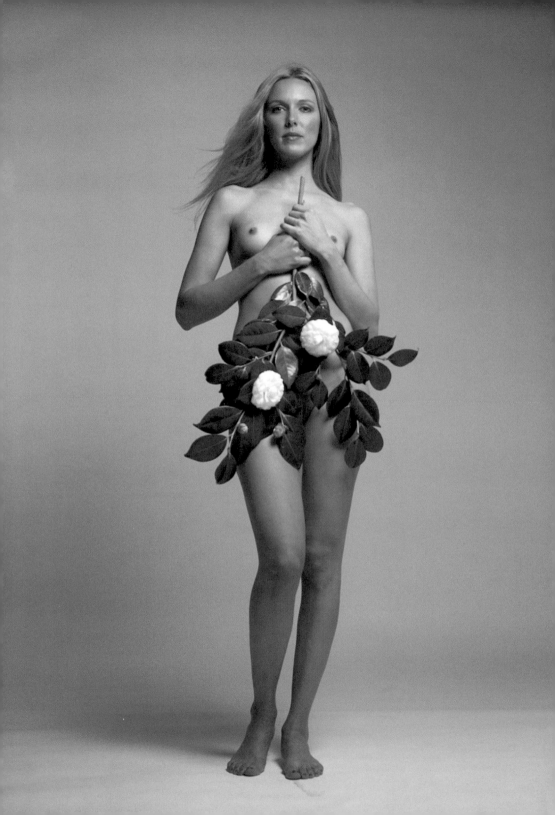

Here are photographs that celebrate the body: its curves, its muscles, its power to attract and impress us. Nudity is as much about

Eros as it is about humility and grace, form and gesture. Whether we are looking at a ballet dancer or a supermodel, we are look-

ing with the appreciative eye of Scavullo, who captures that quality we have come to define as beauty in everyone he photographs.

A turn of the head, a smile, crossed arms, and stretched torsos are all aspects of the nude as seen in these 100 striking images.

Tom,

Here's some food for thought for the "older" athlete — when your body no longer goes fast, it's time to start working on at least making it look good. Hope this will provide inspiration...

Vlad
and
Karin

Let's face it, Francesco dates back. For decade after decade, when beauty and fashion people talk photography, they have talked Scavullo. When you had to have glamour, when you had to have energy, when you had a difficult client, and, most particularly, when you had to get the job done, the mind drifted irrevocably in the direction of Frank. Only those who like him a lot and date back as far as he does ever refer to him as Frank, and never to his face. It's a baby name for someone you could always count on to baby a job through in a first-class way. Francesco Scavullo emerged on the New York fashion scene around the same time as Richard Avedon, Irving Penn, and others were unseating the established photographers of the prewar period. George Platt Lynes, Edward Steichen, George Hoyningen-Huene, Horst, Erwin Blumenfeld, Toni Frissell had all been names to reckon with. Much of their work had been studio photography inspired by the early fantasias

of Baron de Meyer and Cecil Beaton. Scavullo, younger than his peers, was ready to go outdoors, was ready to forget that models should be ladylike or ultrasophisticated, was ready to have fun. This was important: He was truly young and had an impish sense of freedom. In his early pictures you can tell that Francesco liked to frolic and that his models enjoyed frolicking with him. Scavullo made it seem natural for his young women to be having a good time in a sporty, casual way. If men liked them it was because they were amusing to be with, not because they were aloof and difficult to get. Francesco heralded a new idea in fashion and in fashion photography. As the fifties came sailing along, Francesco Scavullo was the major Italian name in fashion photography. True, he wasn't from Italy, but his heritage made him special. He was instinctively earthy. Even in that pretty uptight period Francesco was not concerned about what other people thought of him; he was

concerned with what he thought about them. Like Anna Magnani, Sophia Loren, Fellini, and Antonioni, if you're Italian you can't help but be real. There are the seeds of many trends in the earthy Scavullo work. Peppy movie stars like Doris Day and Betty Hutton, who had come to the fore during and right after the war, typified energy and *reality*. They represented an expression of women much more as they wished to see themselves. There were also the seeds of the sixties in much of the photography that Scavullo was doing early on; the period's freedom and lack of convention was to burst into full bloom in the following decade. Glamour portraiture has been a major keynote of the Scavullo career, but it, too, is different from the work of other photographers. The Scavullo portrait shows its subject at its best, but there always remains the reality of the person within. Perhaps this is the reason for the astonishing longevity of the Scavullo

THE SCAVULLO GLEAM IS ALWAYS THERE. BUT THERE IS SOMETHING MO

career. As in all of his works, the subject is *present*. A personality is cleverly in evidence. This is also true of the photographer. Behind the charm and the social dexterity, there has always been the real person. People who are famous have a perennial interest in being famous, but with Francesco one always feels he has not been consumed by the importance of his own career. Rather, that he is much more consumed by the subject he is photographing. The photograph is about the sitter, not about him. Credit, too, must go to the Scavullo talent for sharing creatively. Through a number of decades his lifetime partner, Sean Byrnes, has provided fashion guidance and styling inspiration. Sean's strong sense of the moment has added zest and immediacy to the Scavullo style, which has always blended fashion fantasy with human reality. Together, the two men have created the strong sense of personality that allows the work of Francesco Scavullo

to defy aging.  And so, on to the nudes, some famous, some not famous, all beautiful in the Scavullo lens. But again, with that difference that *is* Scavullo – that ability to make the subject real.  With many (can we say most?) photographers of the nude there is a desire to make an icon of the body. Edward Weston sought to make the comparisons between forms in nature and the human body. The incomparable George Platt Lynes deified the body, and strove to make bodies as beautiful as the gods. There has always been a tendency to make nude studies a worship of the body. The actual person is rarely there – certainly not the person who is the real subject.  Francesco Scavullo's nudes are not like this. The lighting is beautiful. The person is beautiful. The Scavullo gleam is always there. But there is something more. Once this body gets its clothes on you would recognize this person on the street. The personality has not been abstracted from the form. The saucy dancer

NCE THIS BODY GETS ITS CLOTHES ON YOU WOULD RECOGNIZE THIS

with her twirling tassels is surely just as saucy passing by on the sidewalk, tassels or not. The male nudes, too, are far from beef-cake. Droll or stalwart, poetic or heroic, each is individual.  Again, perhaps the Italian heritage plays a role here, too. From ancient times Italians have found nothing wrong with nudity. It is not off-putting. It is not artificial. If anything, the human being is at its most essential sans clothes.  Photographing celebrities in the altogether can't be easy. They have carefully constructed public personas which they must not risk, with or without their clothing. With Scavullo they can relax, knowing they are in safe hands.  It is a curious thing, this Scavullo combination of great glamour and inner reality. There is always a little pop like fireworks in a Scavullo photograph and even more so in his nudes. And that pop comes not from our being asked to admire the unachievable beauty that we're looking at, but at our being invited to meet the person.

No, we're not being asked to try to imitate this person, we're being asked to enjoy his or her company. There's a big difference. The gallery of famous models, stripped yet revealing nothing, is particularly interesting. Here are Claudia Schiffer, Linda Evangelista, Cindy Crawford, glittering in their glamorous hair styles, glossy makeup, the heterae of our time, accessible to everyone yet available to no one. And yet, and yet. No one knows the beauty business better than Francesco Scavullo, and there is something revelatory here. One *feels* the distance between the young women within and the image without, as their slender arms cross their only slightly curving bosoms. Nude they may be but naked they are not, invulnerable in the image the photographer has bestowed upon them. This is interesting stuff. Could you call it glamour without fantasy? It's an unusual experience. We look at nudes because they're sexy and exciting. Most nudes lead us

PERSON ON THE STREET. THE PERSONALITY HAS NOT BEEN ABSTRACTED FR

into a world of unreality where people don't look like real people or act like real people. Francesco Scavullo has been fortunate enough and talented enough to live in a world that is shared by beautiful people and talented people. Scavullo has lived his fortunes. And when he photographs he shares that world with us. And he shows us that nakedness is thrilling but also real, and if this very person, the dancer Sterling Saint Jacques, for instance, were with us this moment it would be exactly like this. No more, no less. It's not true, but we believe it. Of course the image is heightened with the lighting and the excitement of the moment, but we believe this is how it would be if we were there on the set ourselves. So let us imagine a day in the Scavullo studio, a day when there is a plan to shoot a nude. Shall we say a male nude? Mr. Beautiful appears from the dressing room with hair and makeup people hovering about: what-

ever they did doesn't show. He looks perfect but natural. Francesco goes out onto the studio floor to talk a little bit. The model doesn't clutch his terry cloth bathrobe quite so tightly about him. Francesco calls out "Check his feet." and makeup (a shortish man with shortish hair, dressed in black, natch) pads out with a damp washcloth to check the bottom of the model's feet. They're pretty clean but he gives them another swipe. The model balances on one foot and holds the makeup man's shoulder for balance. The lights go on and Francesco gets down behind the camera, which is low. Very low. He's happy with the look. In his light, singing voice he calls out happily, "Okay, let's go!" and the model turns to face the camera and turns on his lights too. The bathrobe is thrown into the waiting arms of hair and makeup and he's on. And then you notice something. Mr. Beautiful may not be completely beautiful but he has great expressions. His body may not be com-

HE FORM....DROLL OR STALWART, POETIC OR HEROIC, EACH IS INDIVIDUAL

pletely perfect but he can move it radically. Scavullo doesn't say too much from behind the camera. There's a kind of litany of "Yes, yes, yes, yes" coming from behind that lowdown camera. And suddenly you're really not all that aware that the young man in the center of the floor is as naked as a jaybird. He is looking at the camera and Scavullo is looking at his face. What they're creating is erotic, but not erotic in a traditional way. If you get excited about this real guy, you're going to be just as excited about his personality as you are about his solar plexus. That's the Scavullo thing. He takes all the glamour and the lights and the beauty and the excitement and takes it just one step further to where it becomes *real*, instead of leaving it at unreal. You go, Francesco!

*David Leddick*

baredom [not boredom]

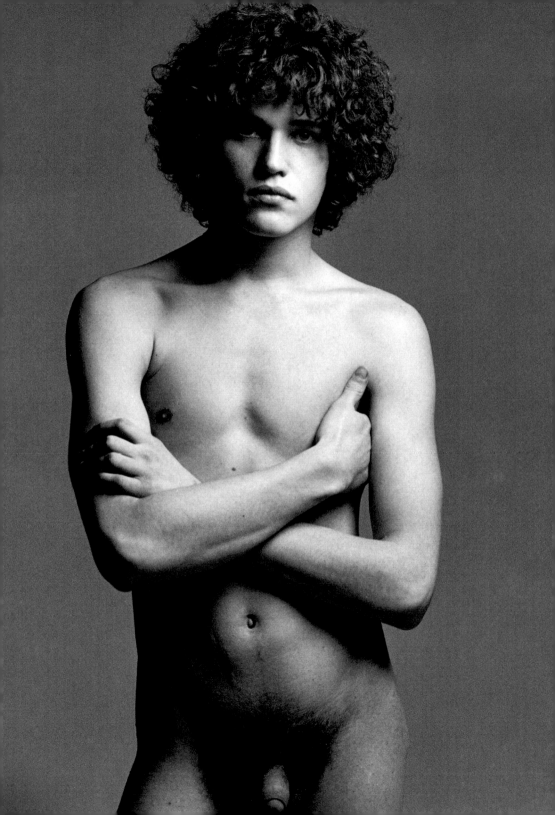

Jay Johnson, 1969

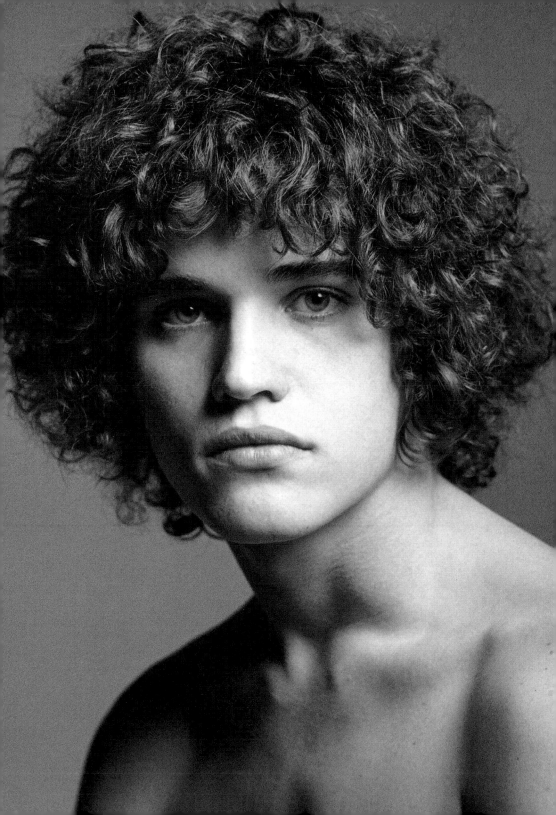

Paul Eckhart, 1971

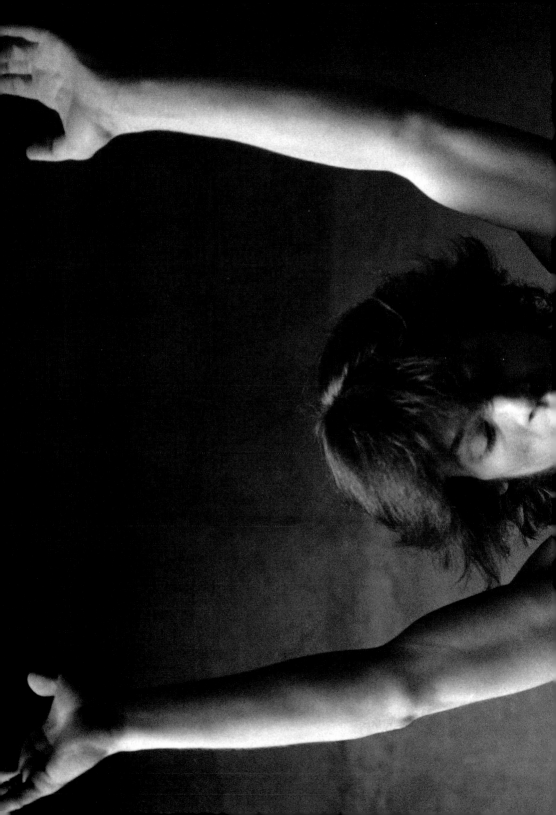

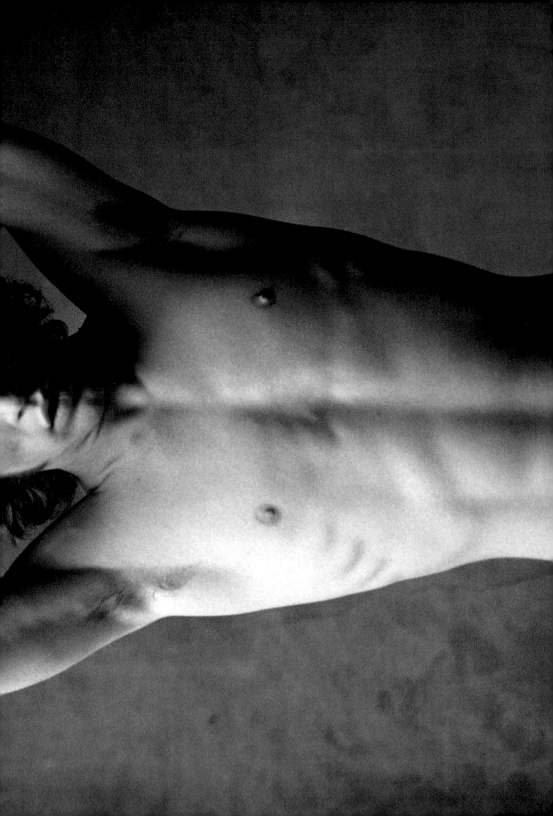

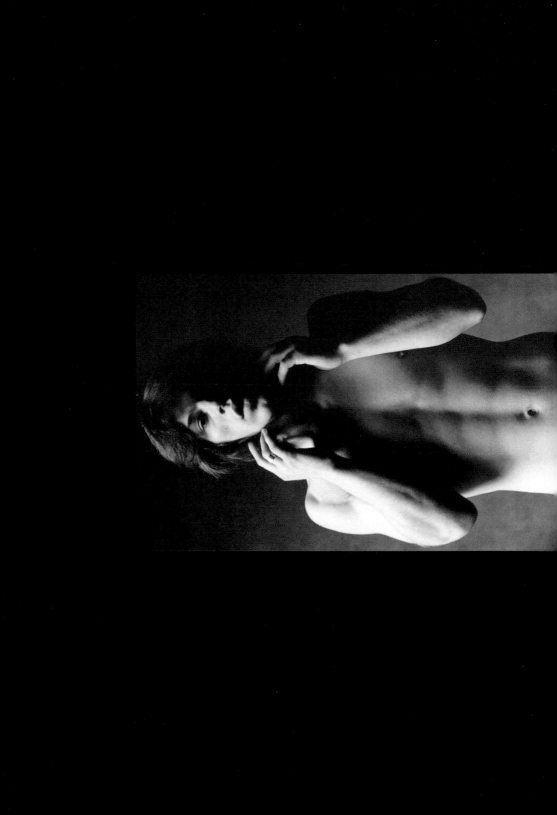

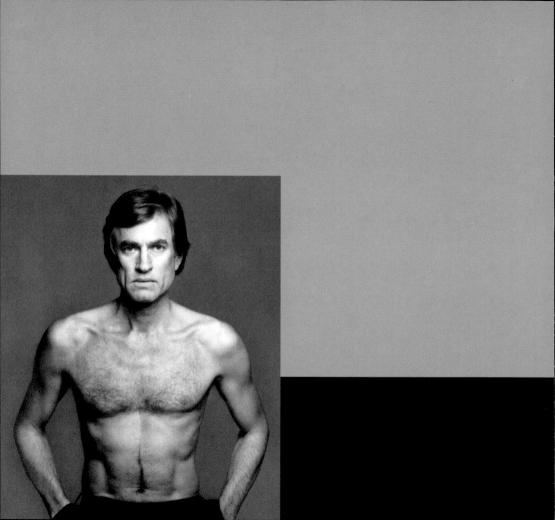

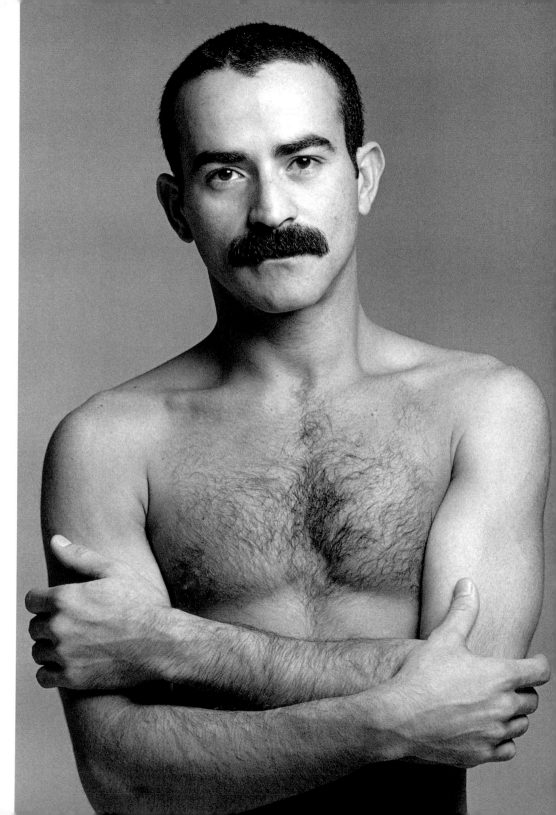

Helmut Berger, 1969

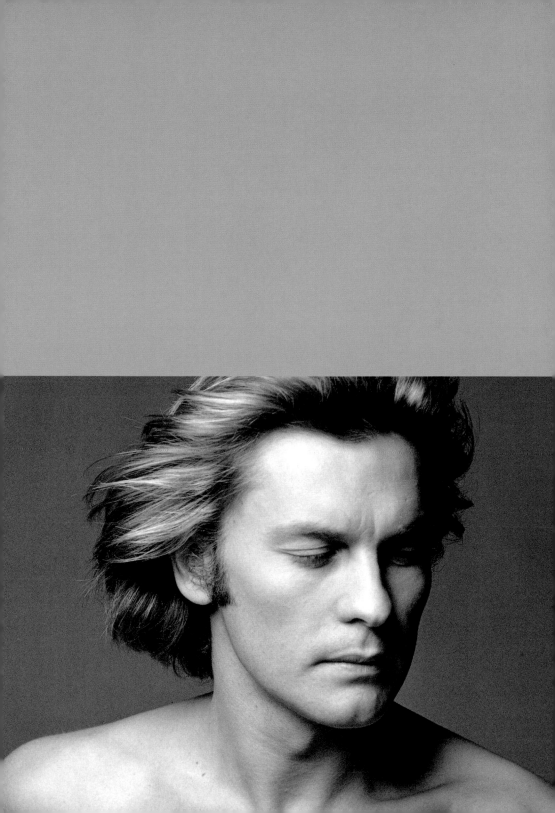

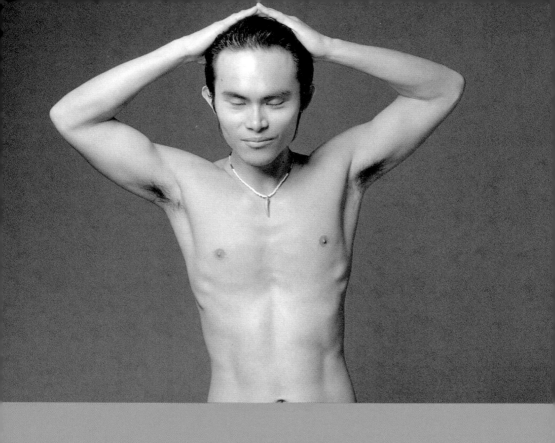

Kevin Woon, 1998

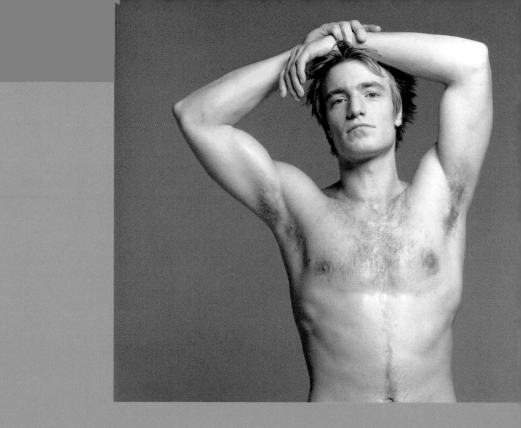

Nikolaj Hubbe, 1998

David Sabedru, 1991

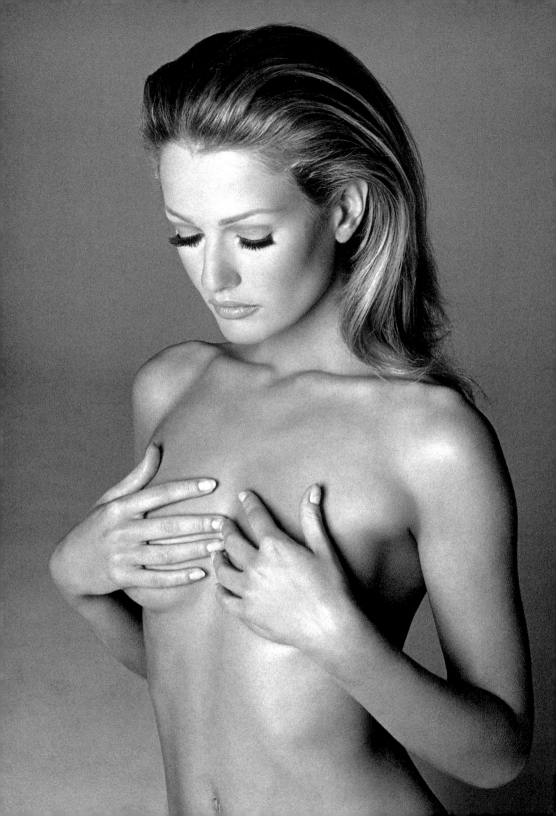

[angels with wings]

Karen Mulder, 1992

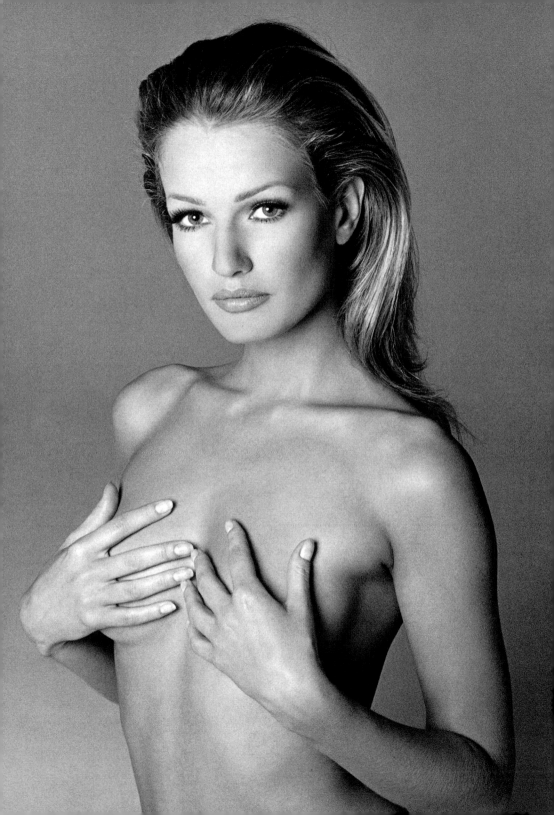

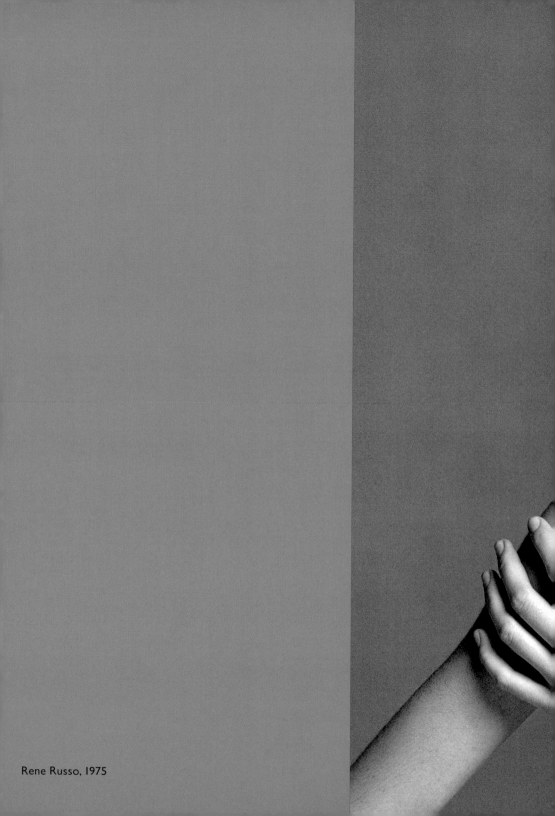

Rene Russo, 1975

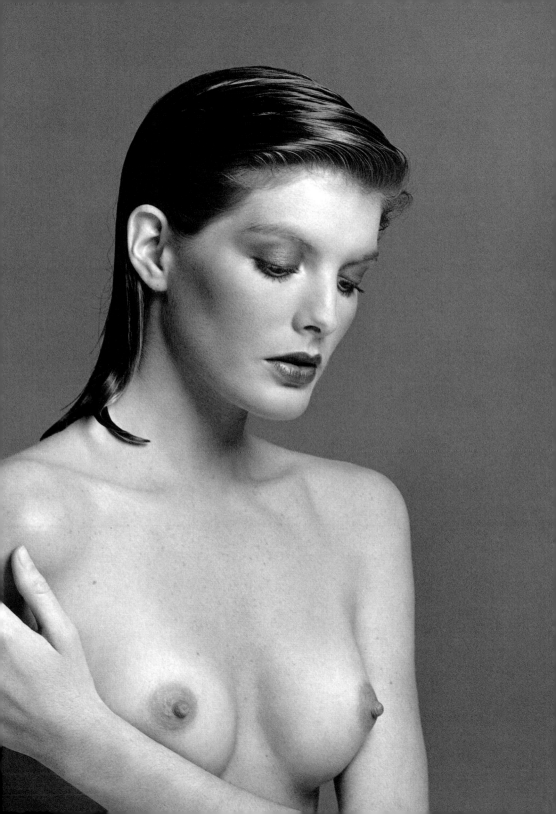

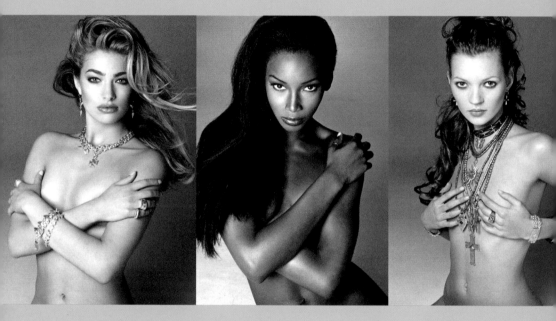

Elaine Irwin, 1991            Beverly Peele, 1992            Kate Moss, 1993

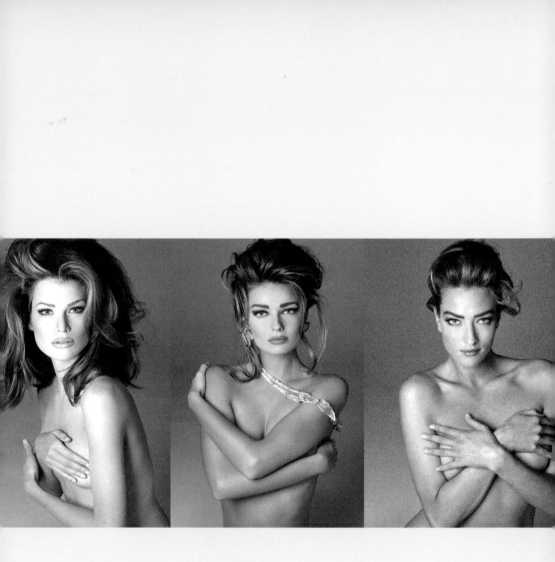

Meghan Douglas, 1992          Paulina, 1991          Tatjana Patitz, 1990

Sarah O'Hare, 1993

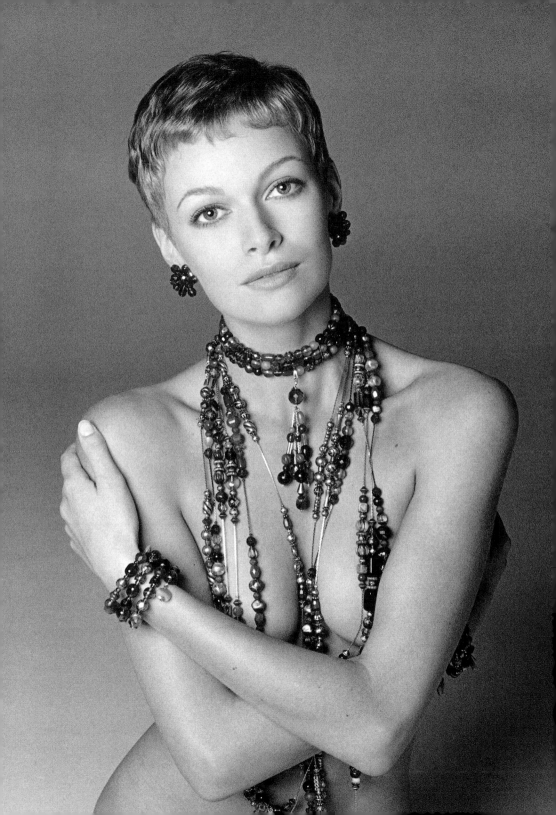

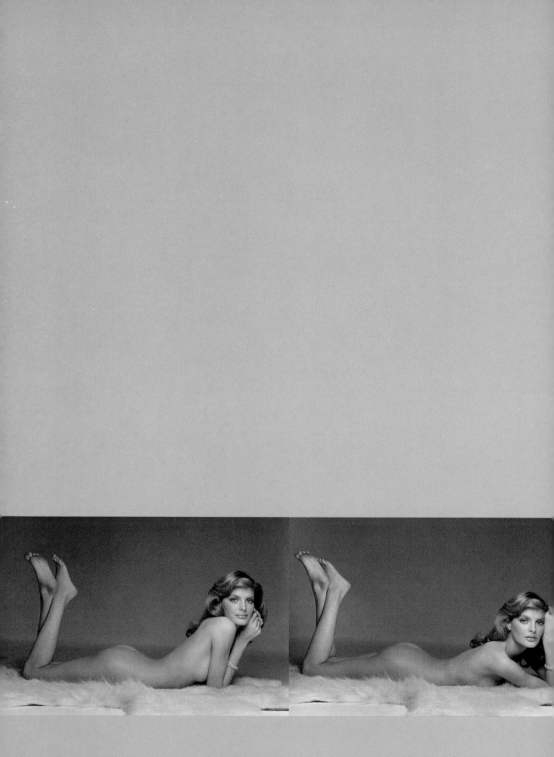

Rene Russo, 1974

painted roses

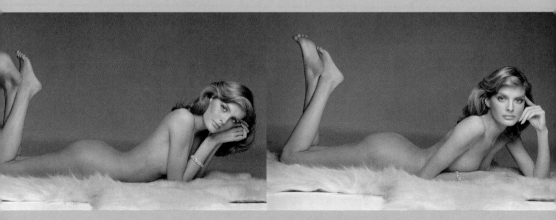

Dana Patrick, 1990

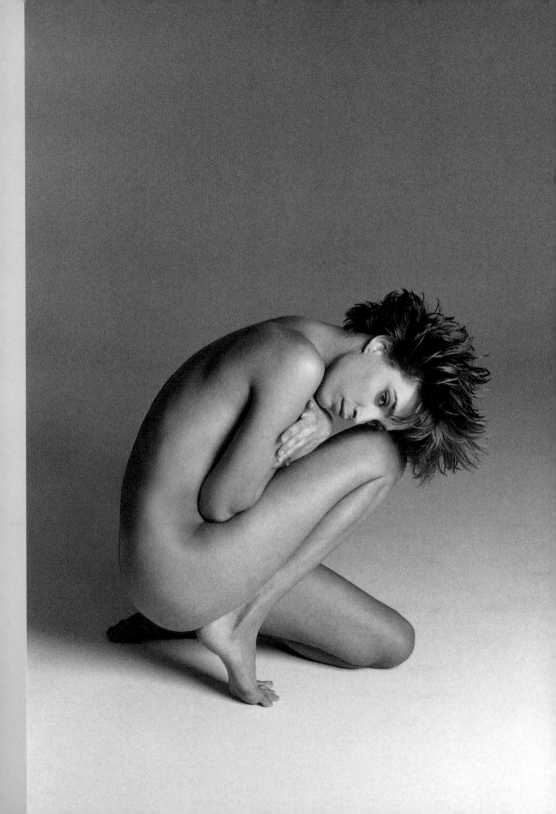

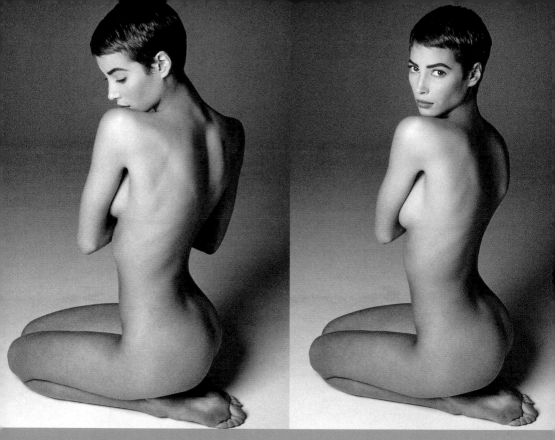

Christy Turlington, 1990

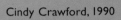
Cindy Crawford, 1990

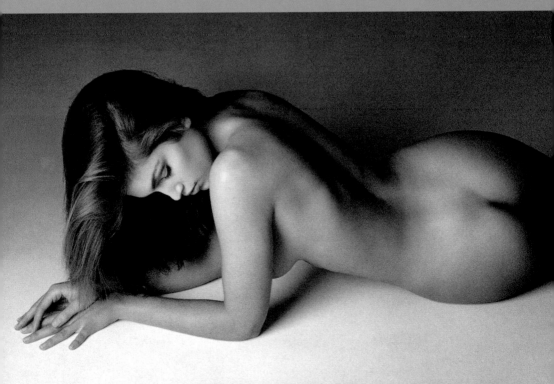

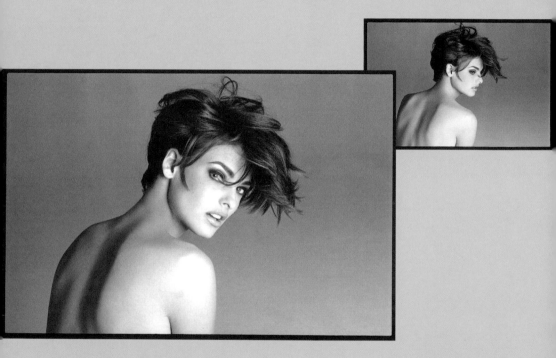

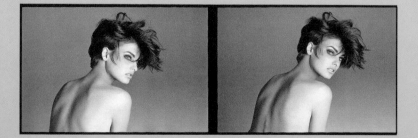

Linda Evangelista, 1990

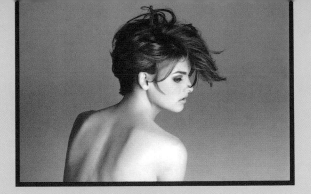

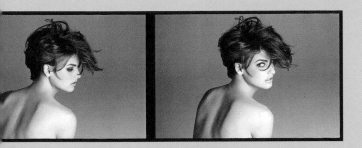

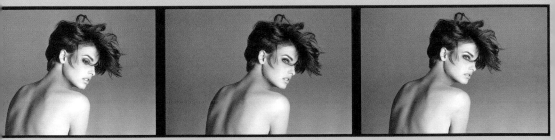

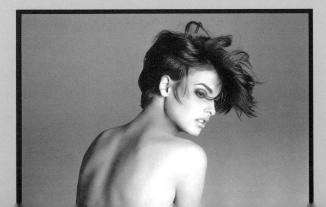

Claudia Schiffer, 1992

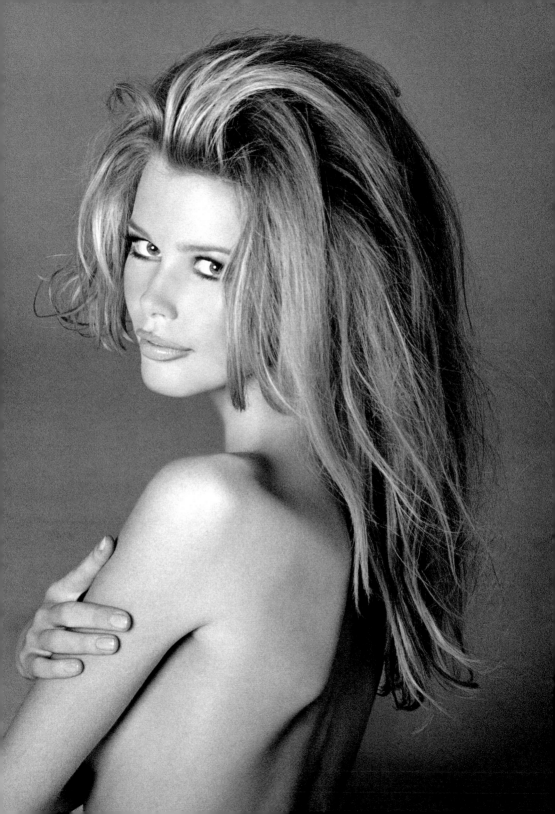

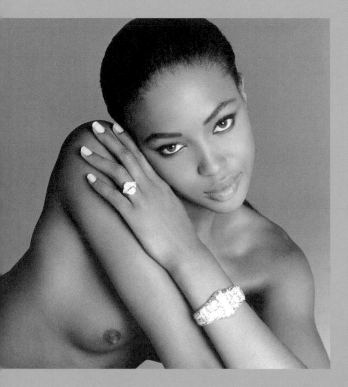

Naomi Campbell, 1989 and 1990

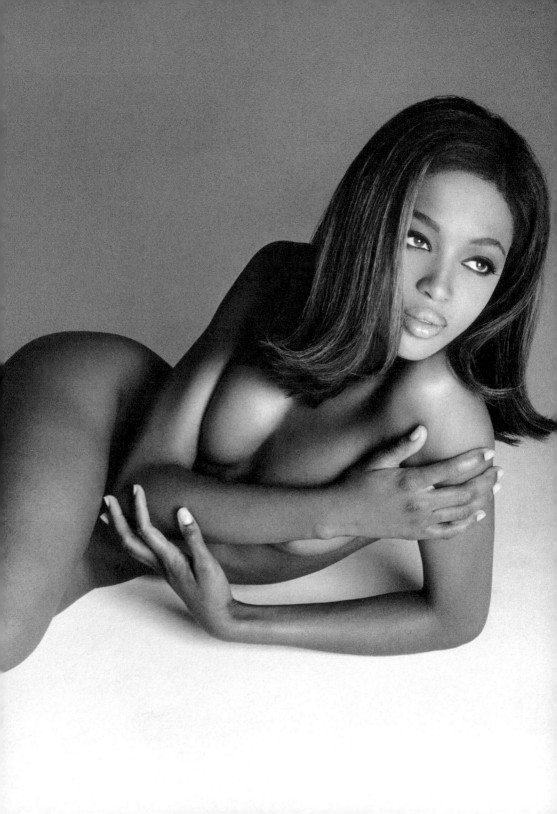

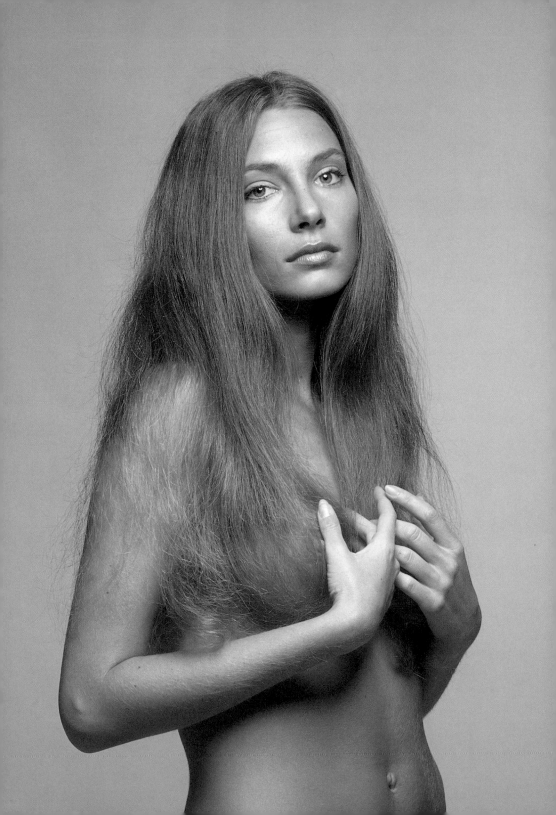

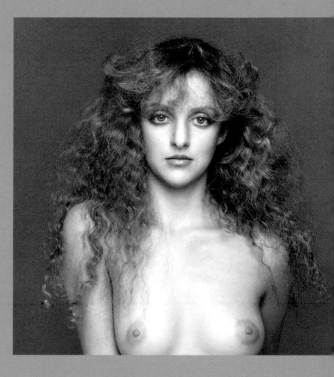

Toni Sotres, 1970

Anna Levine, 1975

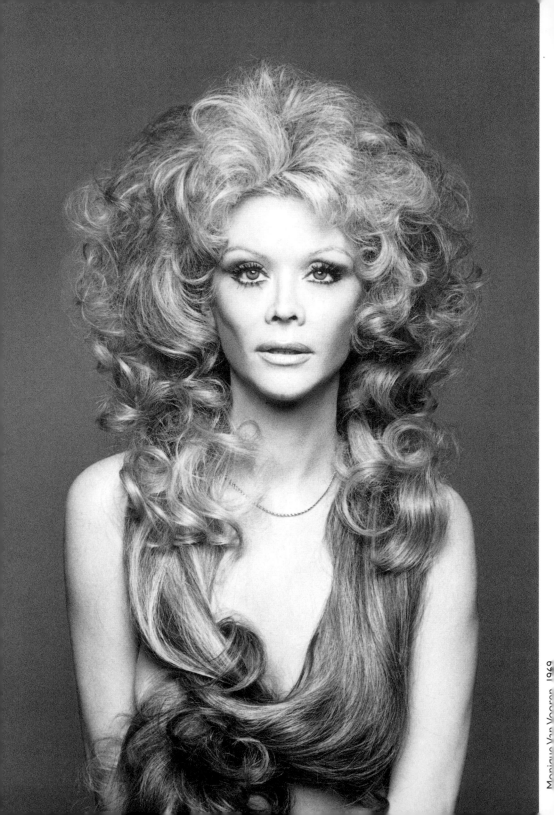

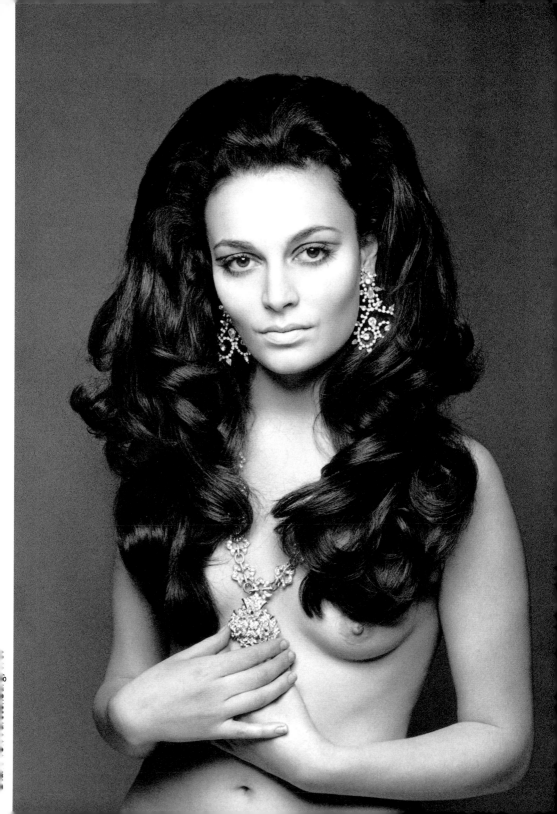

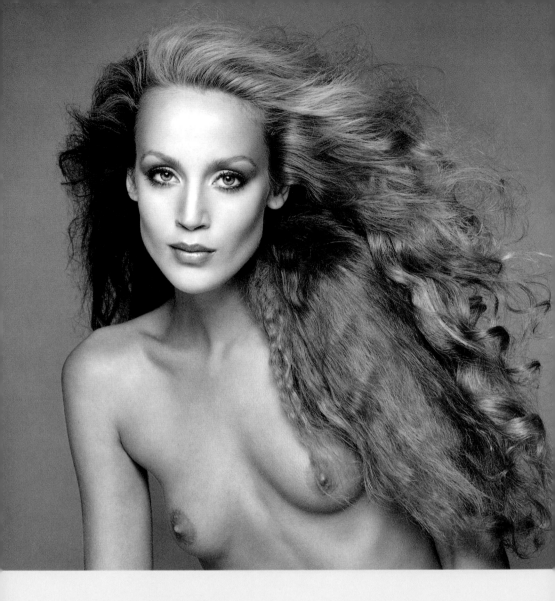

Jerry Hall, 1975

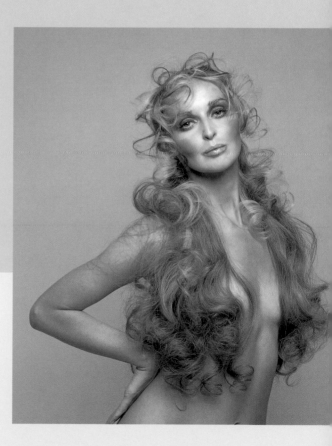

Samantha Jones, 1968

Margaux Hemingway, 1975

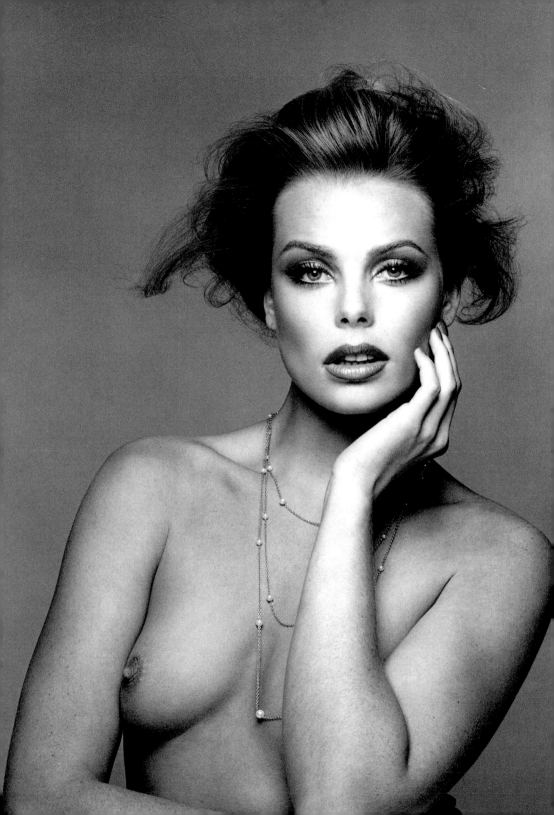

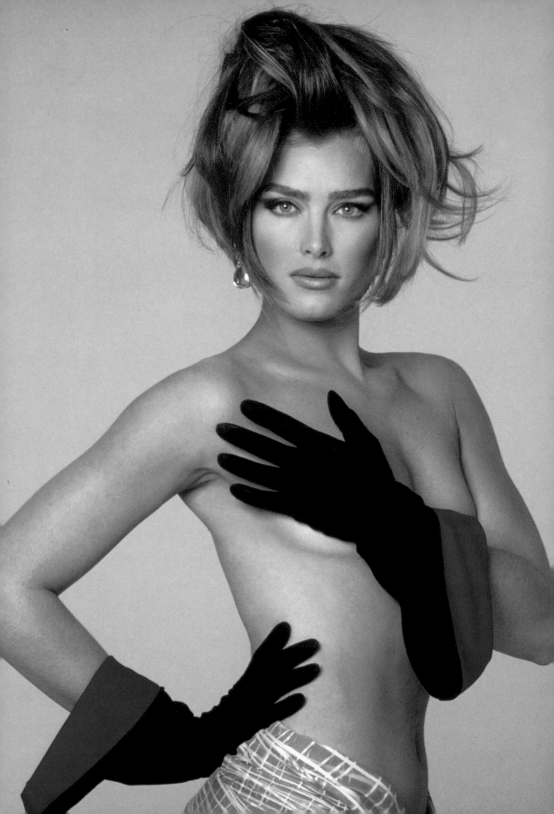

Brooke Shields, 1991

moving + image    [noun + noun]

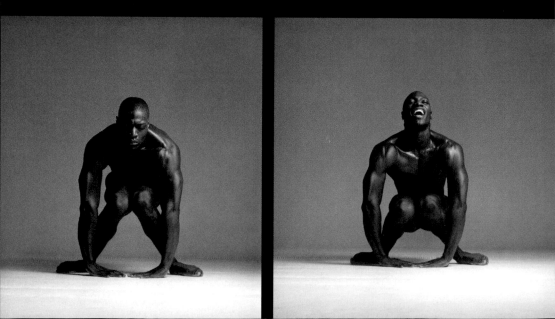

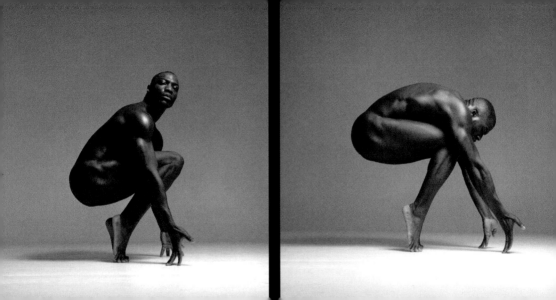

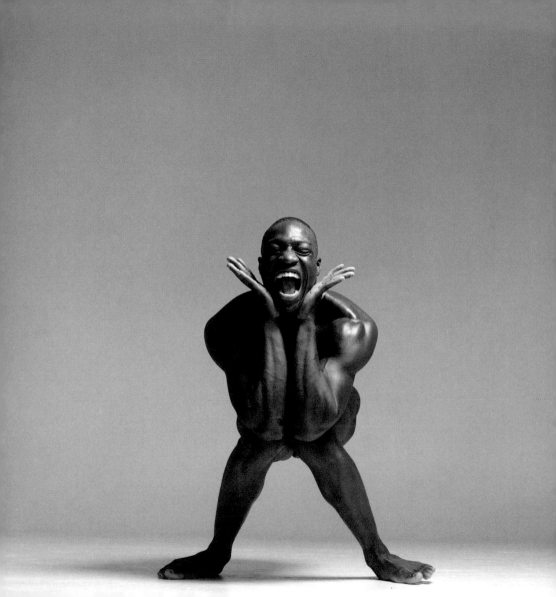

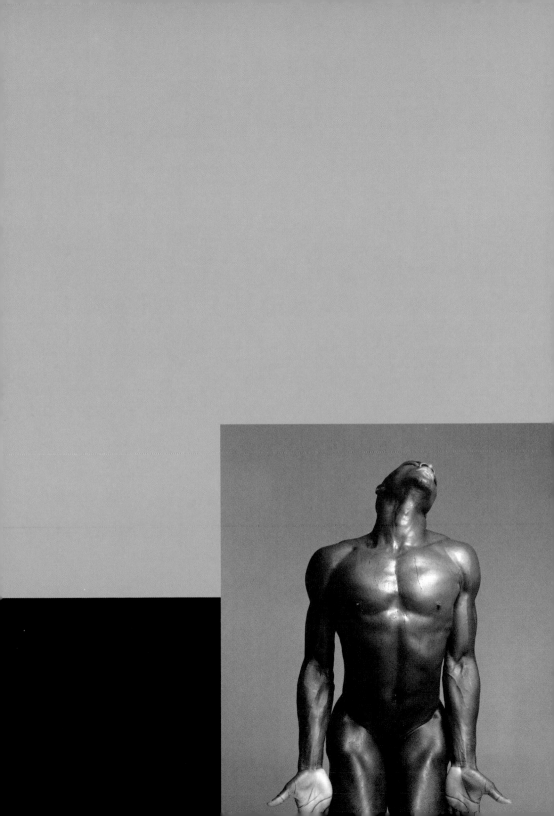

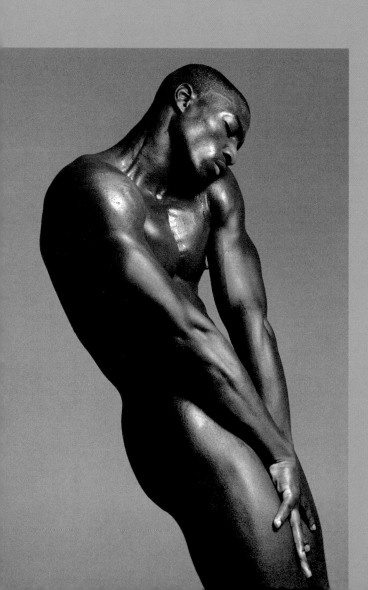

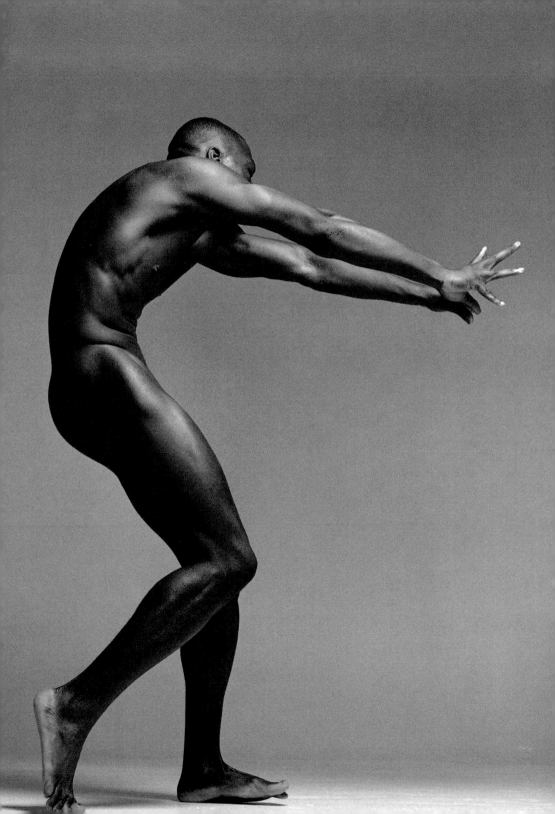

Chris Aceto, 1992

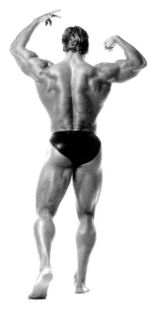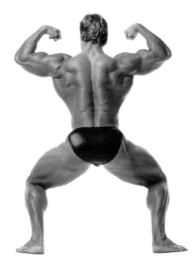

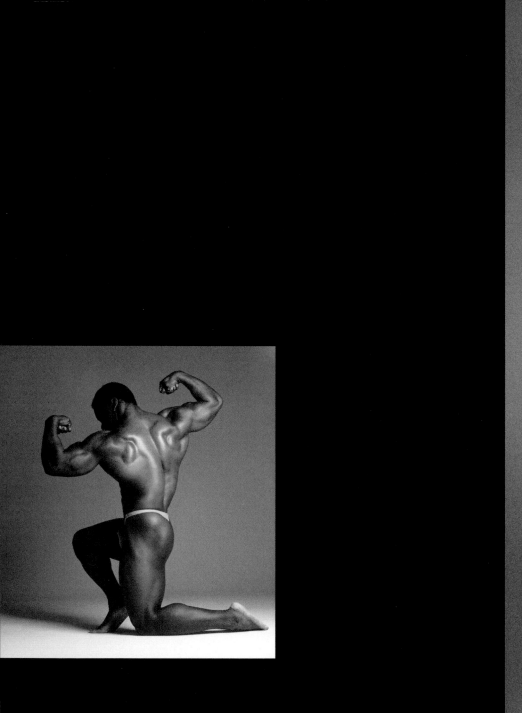

Nick Narvaez, 1990

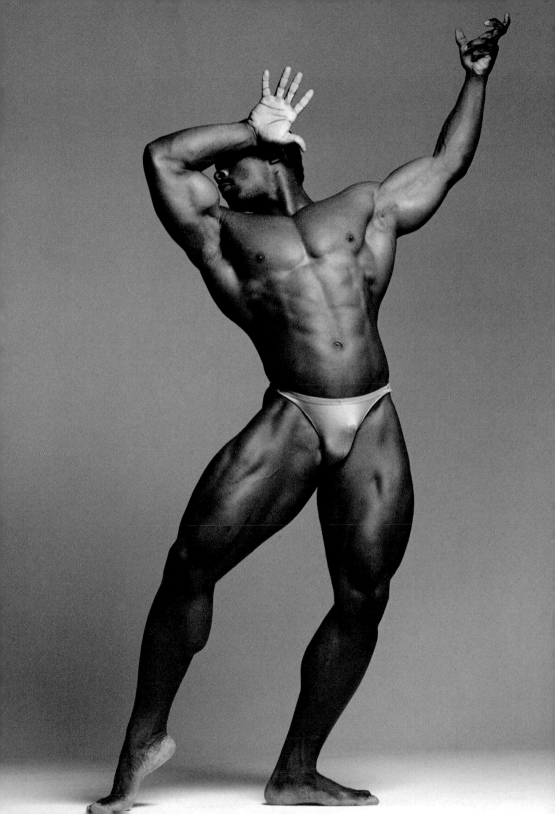

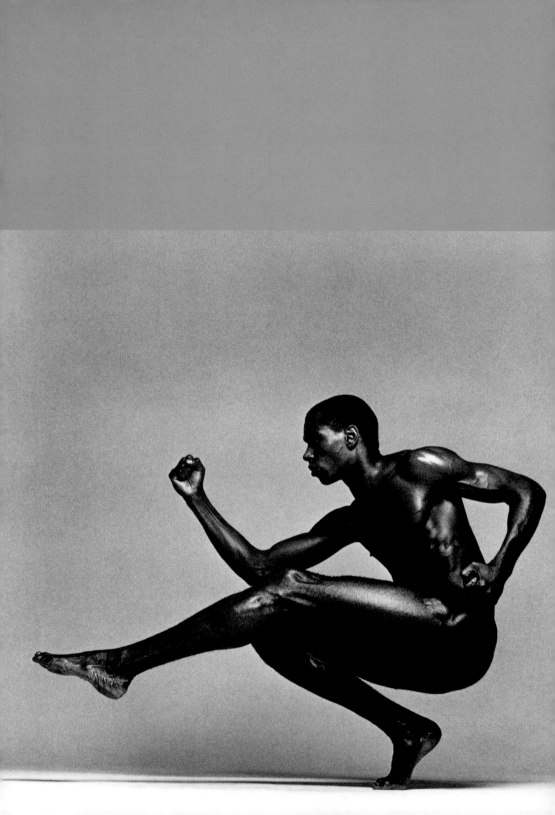

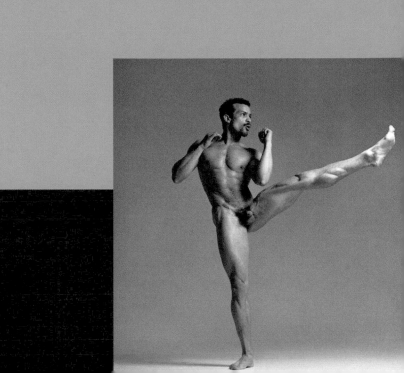

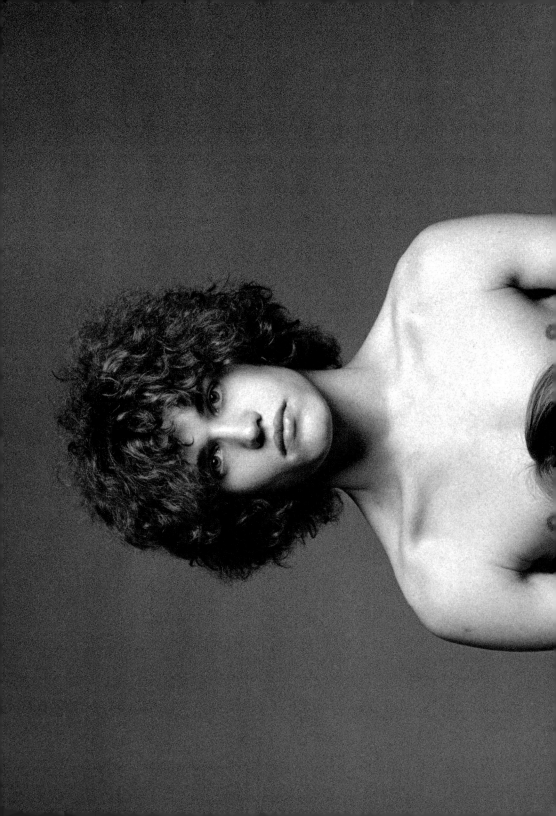

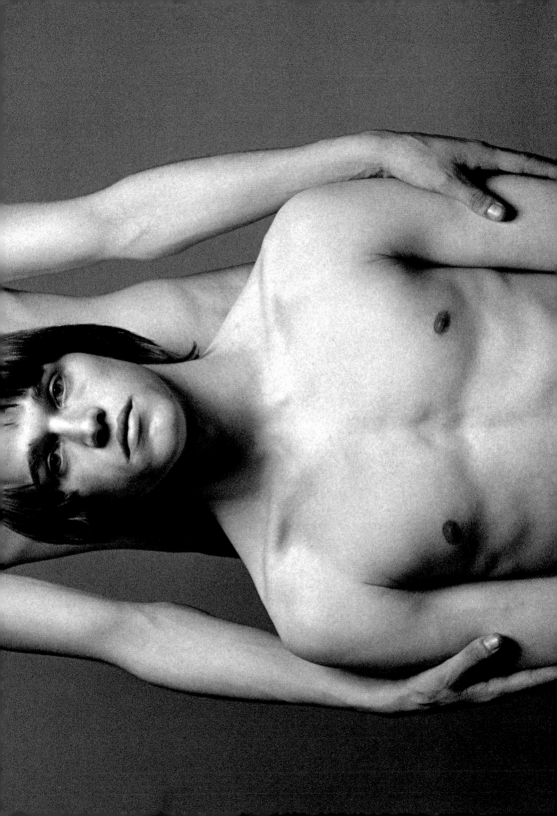

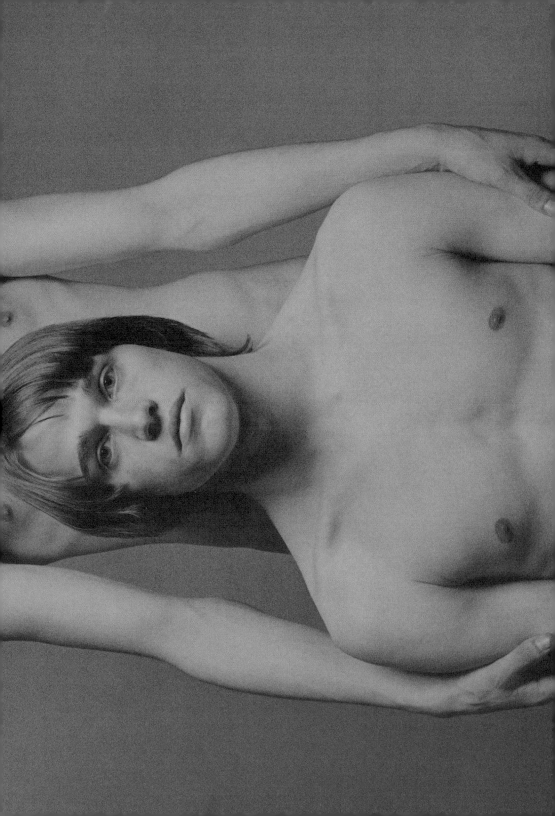

# double exposure

double exposure

Jed and Jay Johnson, 1969

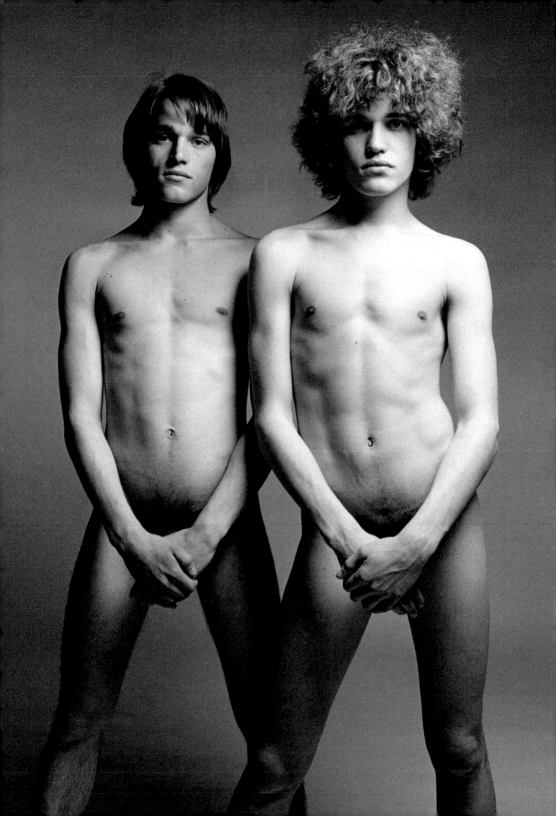

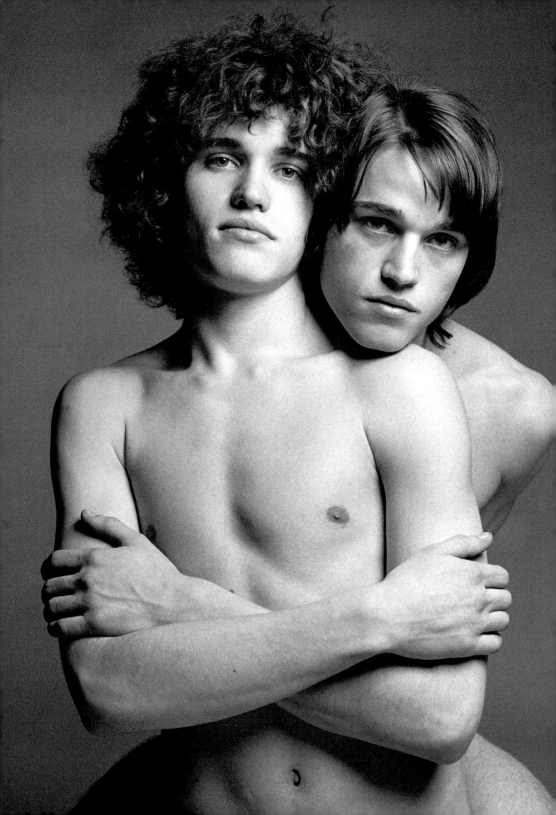

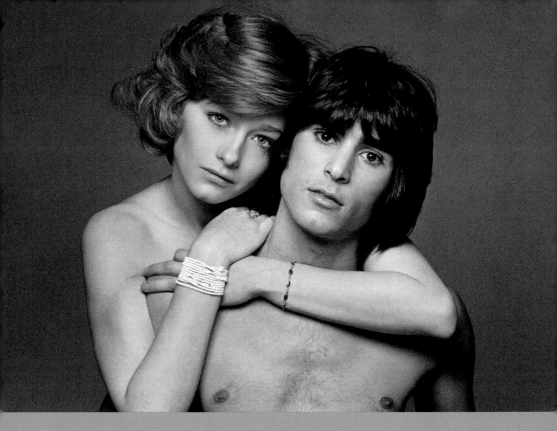

Patti D'Arbinville and Octavio, 1973

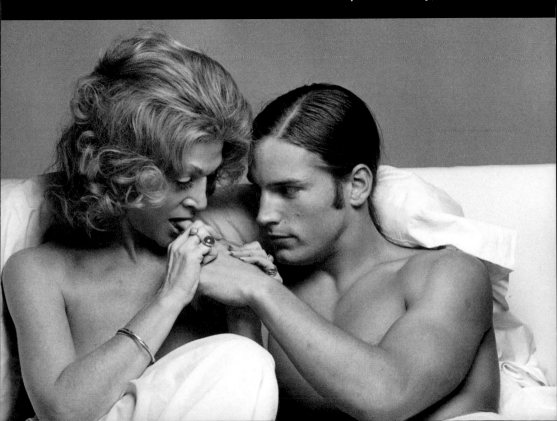

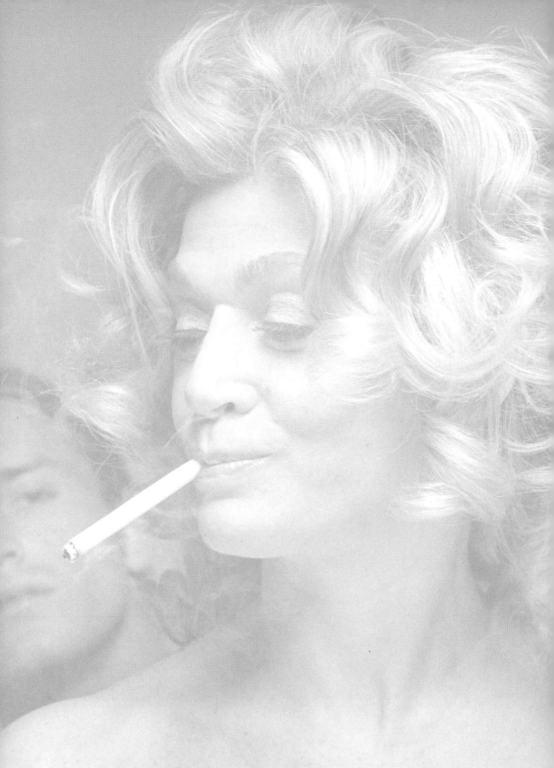

Sylvia Miles and Joe Dallesandro, 1972

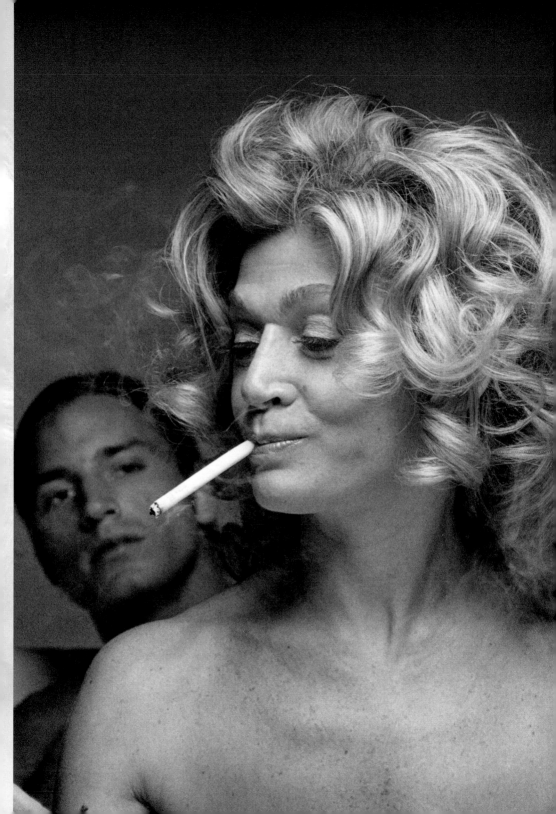

primal dream

Gary Webber, 1969

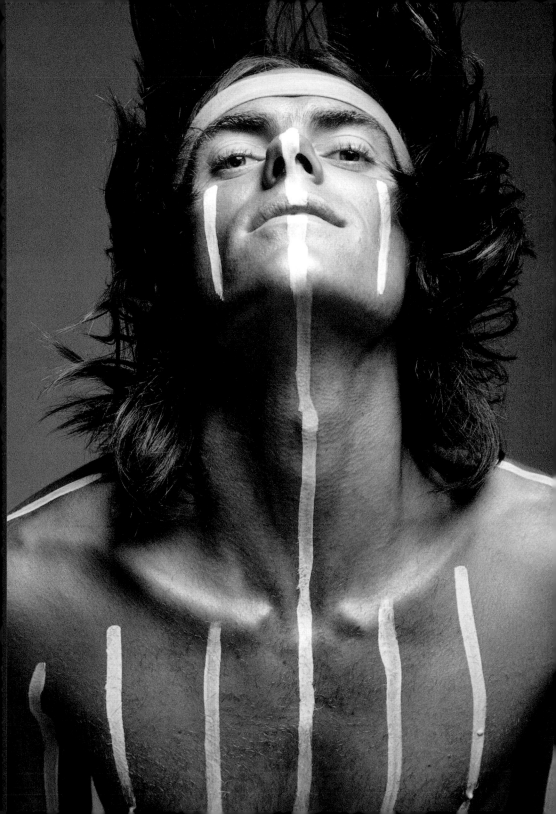

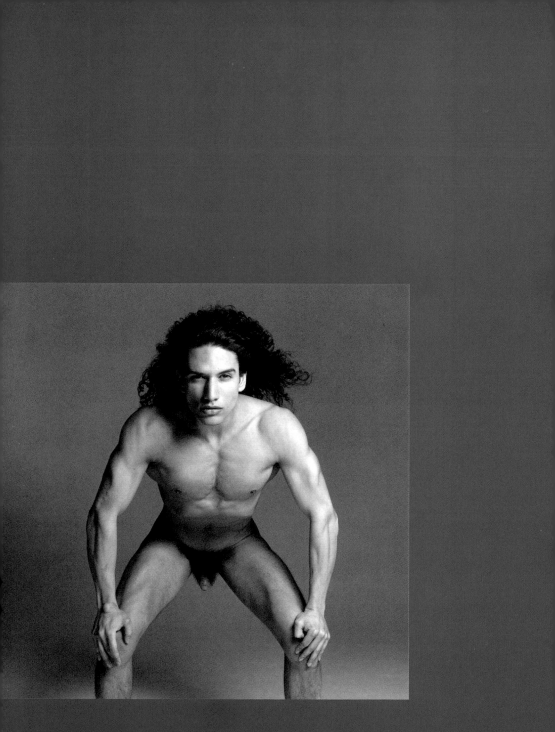

Sergio Valentino, 1993

Diego, 199

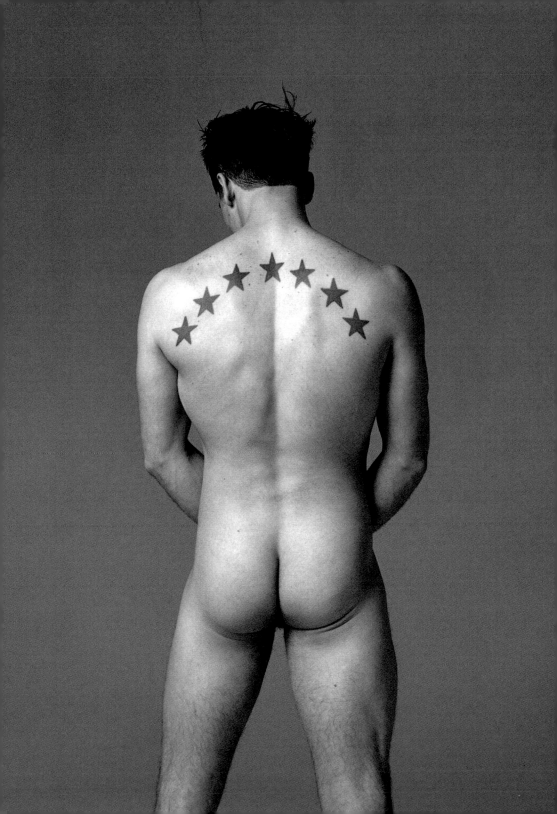

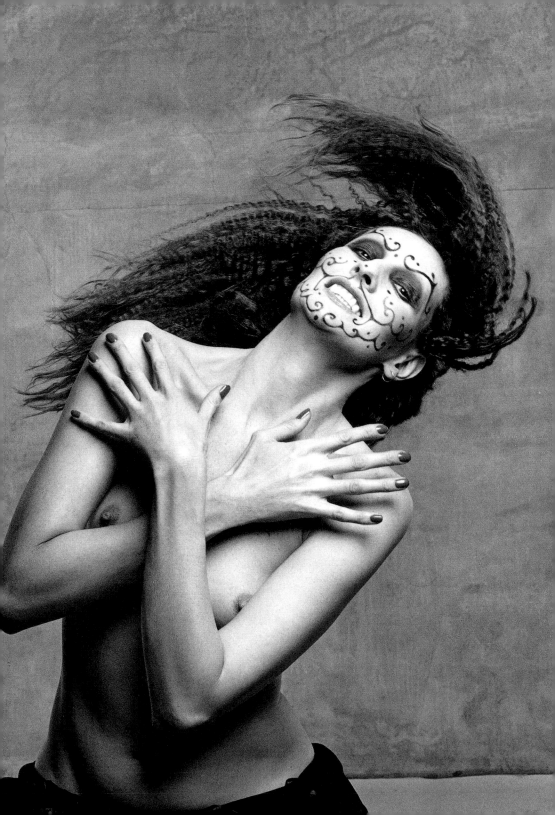

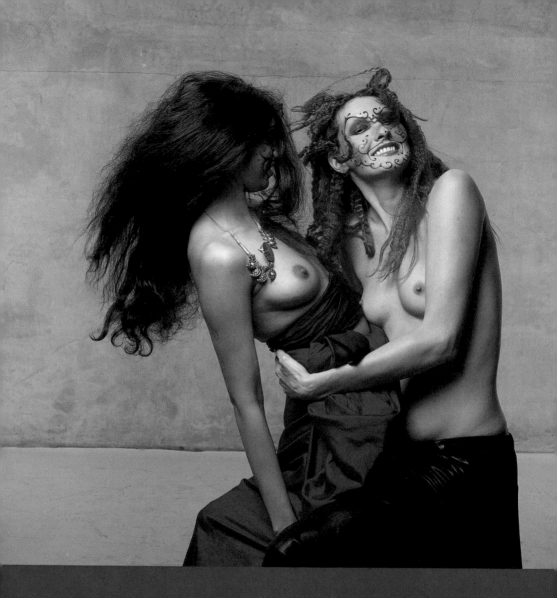

Asha Puthli and Cheyenne, 1970

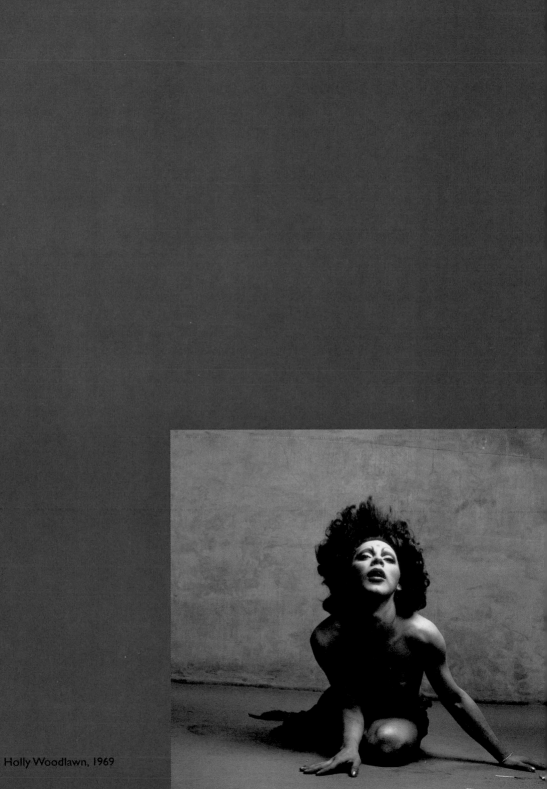

Holly Woodlawn, 1969

Sandy Spencer and Karla Wolfangle, 1971

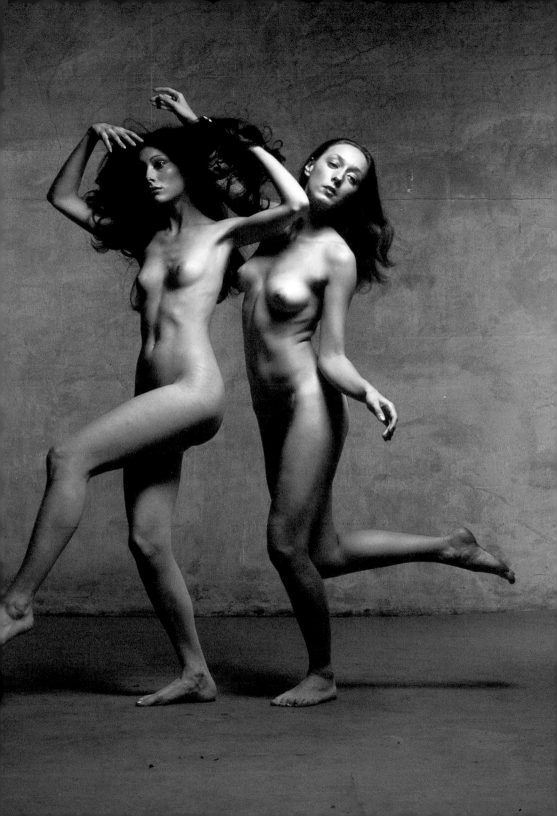

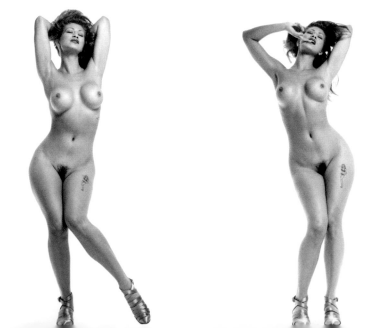

Amber Smith, 1993

exotica erotica

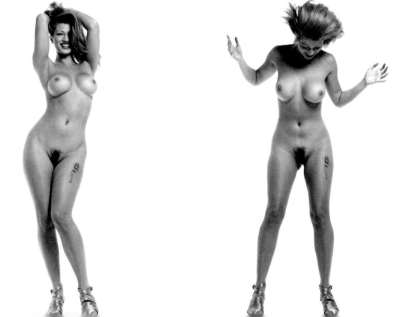

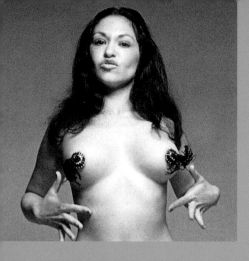

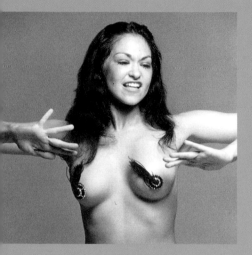

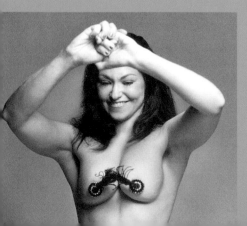

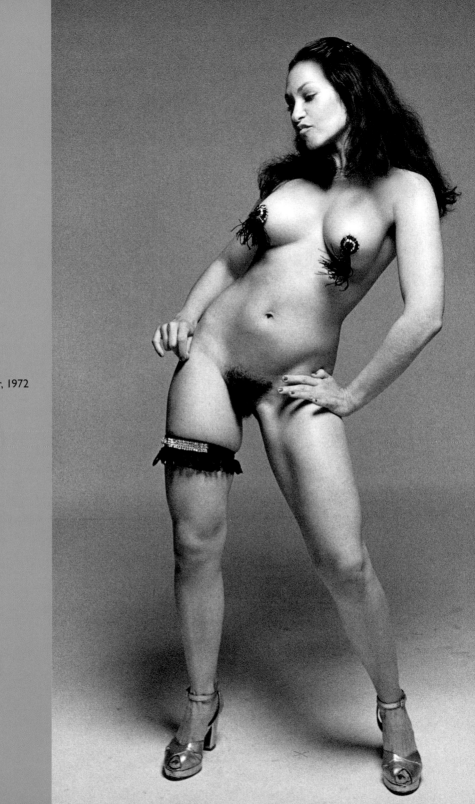

Geri Miller, 1972

Amber Smith, 1993

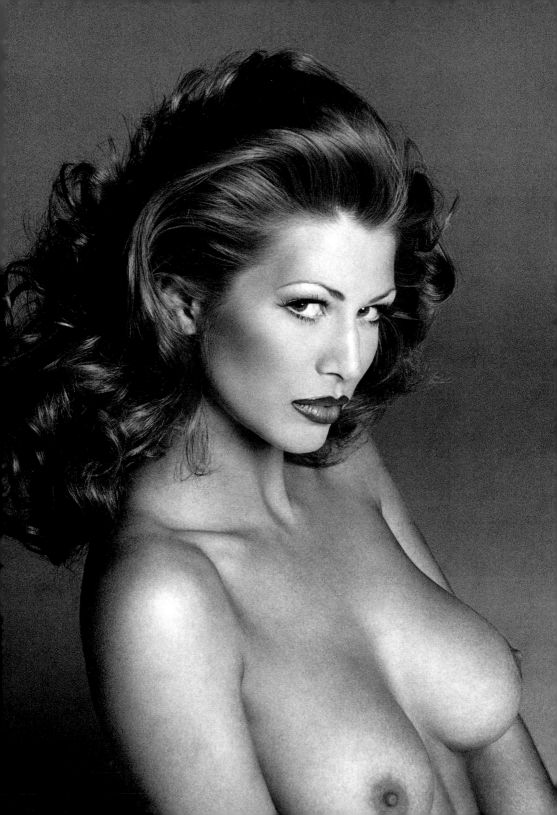

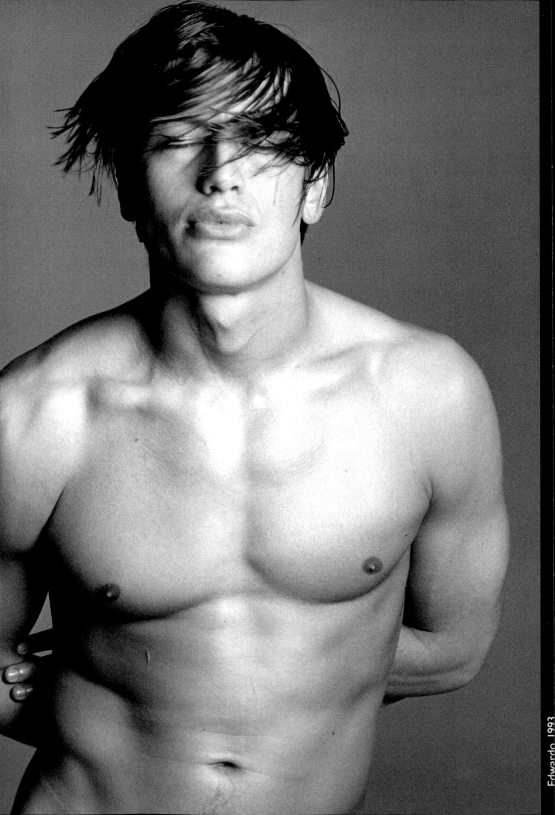

Edwardo 1993

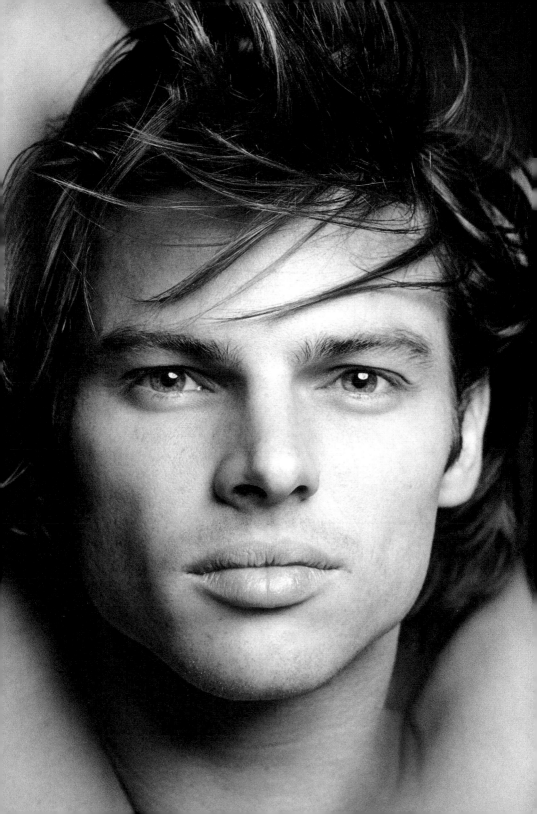

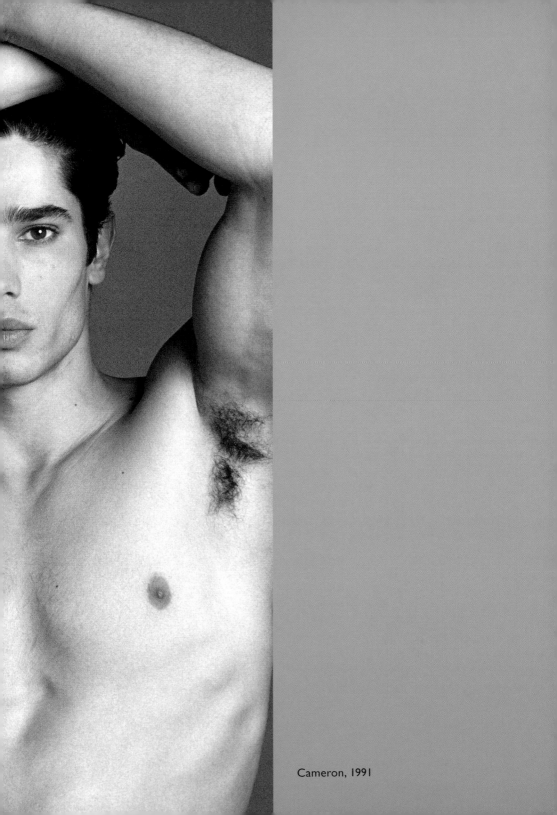

Cameron, 1991

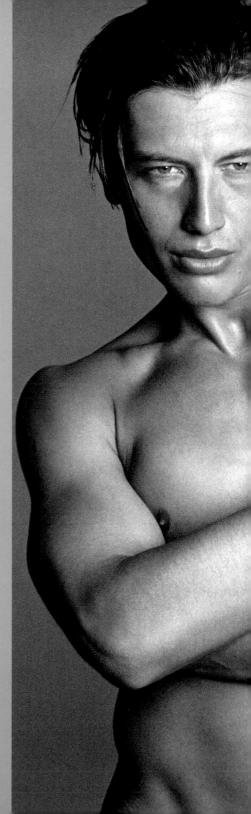

Edwardo, 1993

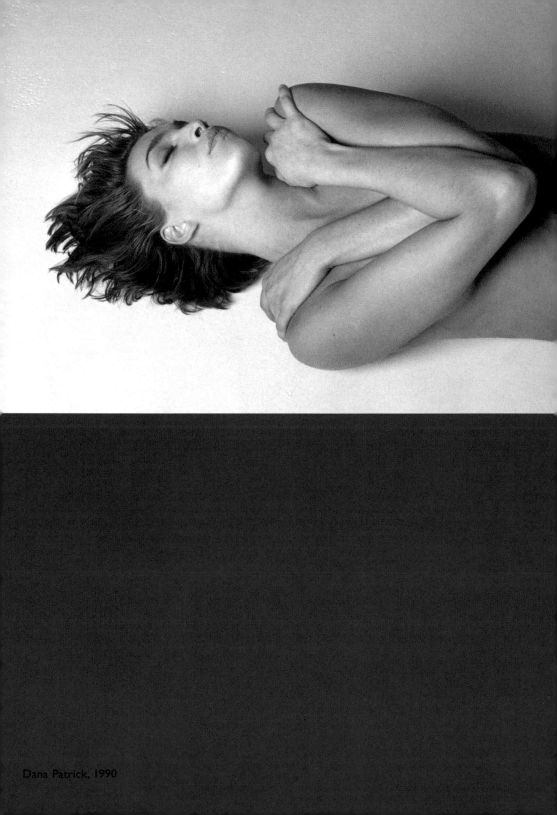

Dana Patrick, 1990

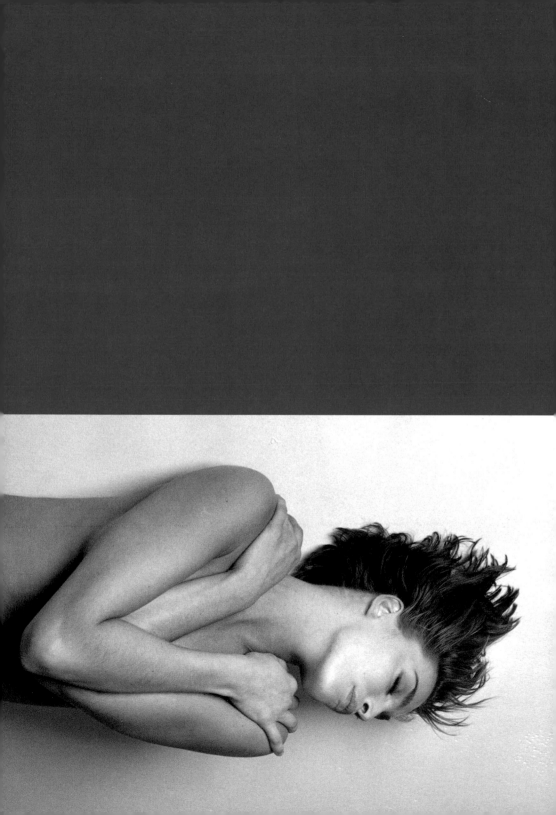

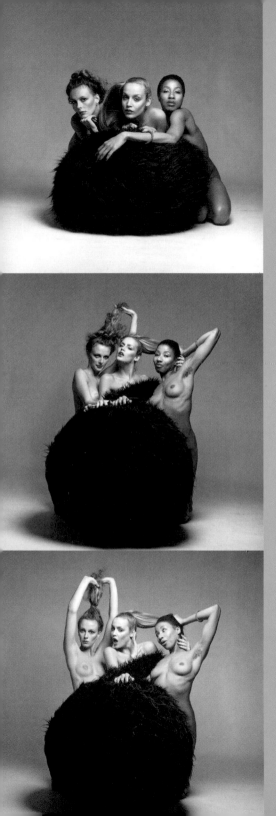

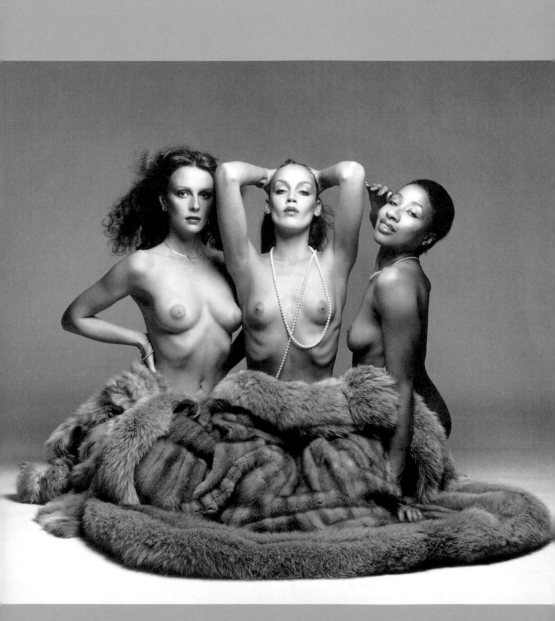

Margaret Broderick, Jerry Hall, Alvenia Bridges, 1975

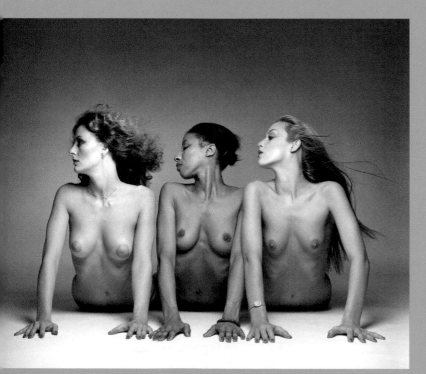

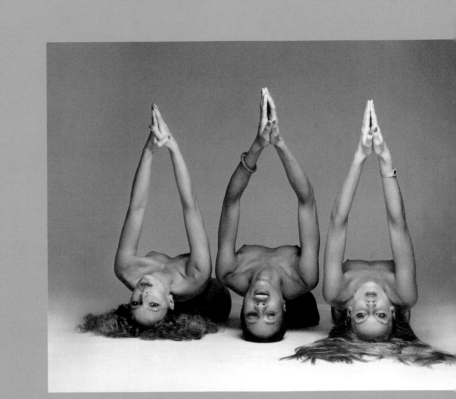

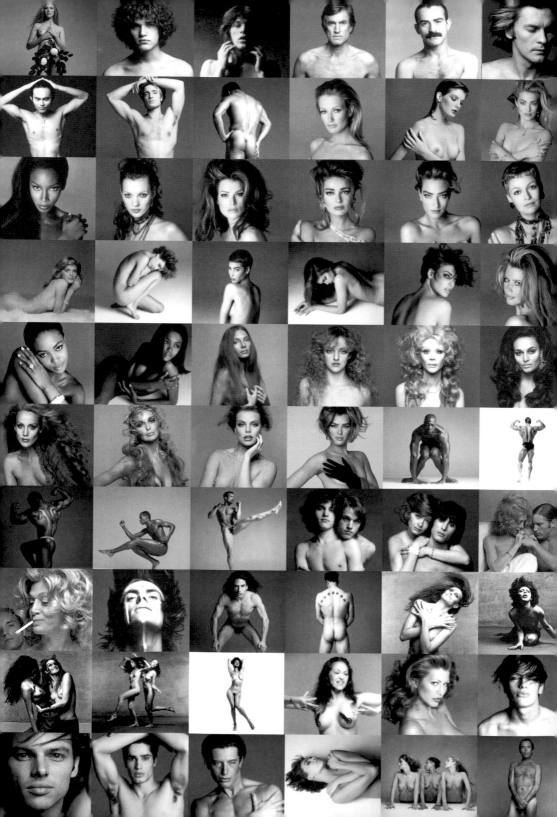

**LIST OF PLATES**

*This book is dedicated to Sean M. Byrnes*

ACKNOWLEDGMENTS

I wish to thank my staff for all their work, now and over the years: Gal Harpaz, Michael

Gonnella, Eric Perkins, Sean Byrnes, Scott Macomber. At Abrams, it was a pleasure

to work again with my editor, Ruth Peltason, and designer, Judith Hudson. I also want to

extend my gratitude to Paul Gottlieb, Abrams' publisher and editor-in-chief; my agent,

Robert Lantz, and his assistant, Dennis Aspland; my lawyer, Peter R. Stern; Dena Bunge,

editorial assistant at Abrams; and David Leddick, for his warm introduction to my book.

The black-and-white prints for this book were made by Kelton Labs in New York; my

special thanks there go to Chuck Kelton, Shelton Walsmith, and Chris Schwer. All retouching

was done by Chris Bishop of Bishop Studios.

Francesco Scavullo
*New York, New York*

PHOTOGRAPH CREDITS

Samantha Jones, courtesy of Hearst Corporation; Sandy Spencer and Karla Wolfangle, courtesy of *Playboy;* Gary Webber, courtesy of *After Dark.*

LIBRARY OF CONGRESS CATALOGING-IN-PUBLICATION DATA
Scavullo, Francesco, 1929–
Scavullo nudes/edited by Ruth Peltason and Judith Hudson; introduction by David Leddick.
p.        cm.
ISBN 0–8109–4195–3
1. Scavullo, Francesco, 1929–   2. Celebrities—Portraits.  3. Portrait photography.
4. Fashion photography.  5. Photography of the nude.  I. Peltason, Ruth A.  II. Hudson, Judith.
III. Title
TR681.F3.S322 2000
779'.21'092—dc21                                                  99–45969

Printed and bound in Japan

Harry N. Abrams, Inc.
100 Fifth Avenue
New York, N.Y. 10011
www.abramsbooks.com

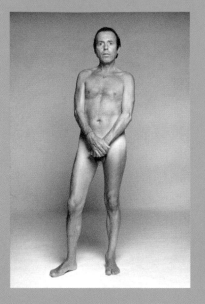

ABOUT THE AUTHOR

Scavullo, who was known for undressing "everyone" in the 1960s and who later went
on to become among the best dressed in the 1980s, was once asked in an article for
Andy Warhol's *Interview* magazine why he asked his models to take off their clothes.
His answer was simple: "I never ask anyone to do anything that I wouldn't do myself."
Scavullo is the author of several books, most recently Abrams' *Scavullo: Photographs
50 Years*. He lives in Manhattan and Southampton, New York.

self-portrait, 1972